...unny. Trace a stencil or printed alphabet letter. Add a ...ng bunny, a vine, and a shadow. Add color with col... ...ncils.

WHAT IS ...RABUNDA?

FloraBunda ... new collection of simple, easy-to-draw, nature-inspired art doodles that you can use to create your own unique art. Whether you already love drawing or have never thought of yourself as someone who can draw, you'll find the simple shapes of the plants and critters of FloraBunda easy to learn. Birds, trees, and insects flow effortlessly from your hand through your pencil, pen, or marker as you create a fantastical forest. It is fun to mix and match images from nature to develop one-of-a-kind creations. Simple steps for drawing and coloring are included in this book to get you started. In no time you'll be creating gorgeous art and watching your forest grow.

THE MAGICAL FOREST

In the previous books, *FloraBunda Style* and *FloraBunda Basics*, you discovered bountiful blooms and growing things to create a beautiful, natural garden of art. With *FloraBunda Woodland*, you will discover a new world of forest flora and fauna. Capture the joy of exploring a woodland as you turn blank paper into beautiful art. What will you find in your forest? Are there flying owls or birds sitting in the trees? Can you feel the sunlight dappling the leaves, spotlighting ladybugs and grasshoppers? It's time to pick up your pen and find out. Whether you are filling a journal page or creating art for your home, the beauty of nature comes through in simple drawings that grow naturally. From the smallest snail to the biggest buffalo, from the tallest tree to the smallest shrub, I encourage you to try your · hand at all the designs. Start with simple lines, add details, and before you know it, you have a page full of wildlife.

Tree of Life. Showcase your favorite critters in a traditional tree that connects earth and sky. Populate the branches with small critters and birds while bigger animals wander across the foreground.

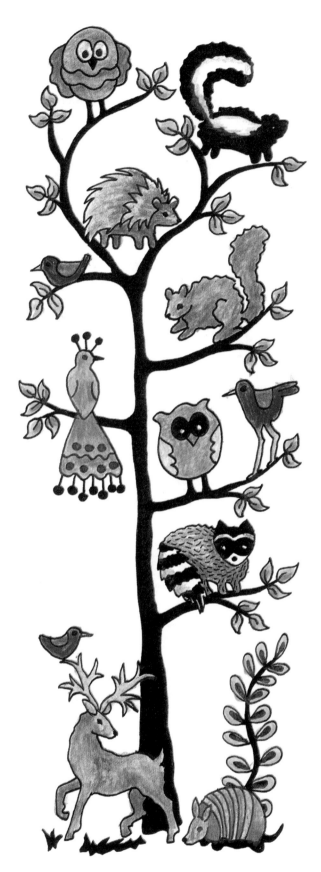

ADDING COLOR TO DESIGNS

Color brings drawings to life. Use a variety of techniques: colored pencils, markers, watercolor pencils, and watercolors. Experiment and enjoy the creative journey. See more info on coloring on page 7.

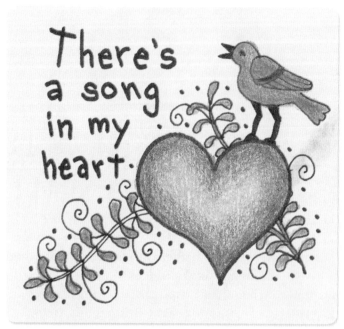

There's a Song. Draw a heart and words with a black Pigma #1 Graphic pen. Outline a bird and vine with an .03 Pigma MICRON pen. Using colored pencils, color the inside of the heart, adding additional layers to gradate the color.

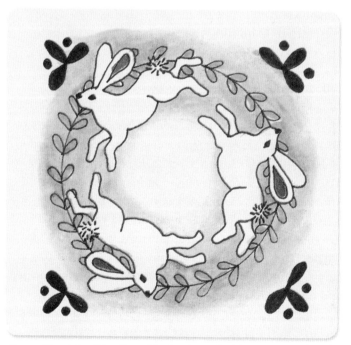

Tree of Life. Populate tree branches with small critters and birds. Outline each animal with ink. Add color to the animals with colored pencils.

Bunny Mandala. Give the gift of art created by your own hand. Draw a circle with a light pencil line. Draw the bunnies with ink, turning your paper as needed. Ink over the parts of the circle that show and add leaves. Embellish the corners with leaves and dots. Color with watercolor markers (Tombow or Koi) and a blender pen.

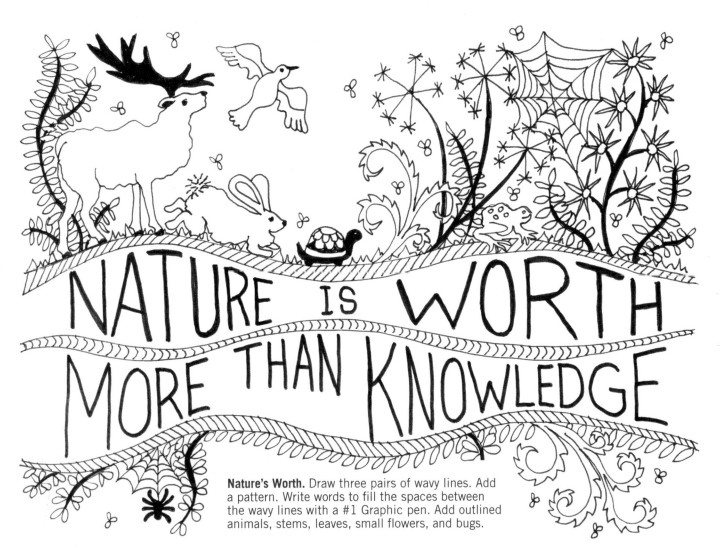

Nature's Worth. Draw three pairs of wavy lines. Add a pattern. Write words to fill the spaces between the wavy lines with a #1 Graphic pen. Add outlined animals, stems, leaves, small flowers, and bugs.

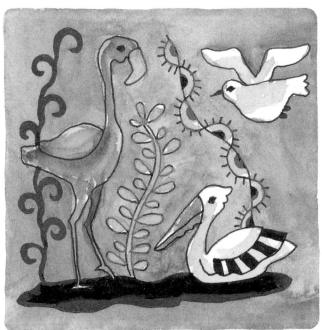
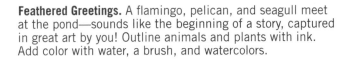

Feathered Greetings. A flamingo, pelican, and seagull meet at the pond—sounds like the beginning of a story, captured in great art by you! Outline animals and plants with ink. Add color with water, a brush, and watercolors.

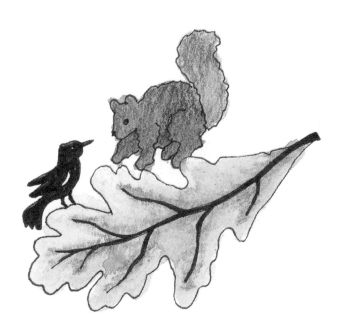

Lovely Day for a Leaf. I wonder what this squirrel and bird are talking about? Outline a large leaf and animals with ink. Use watercolor pencils to add color.

DRAWING BASICS

Black permanent ink pens come in several sizes, or line widths. Use black .03 MICRON pens to draw outlines of flora and fauna. Use an .01 pen for thin accent lines. Use .08 pens and #1 Graphic pens for thick lines and for filling in black backgrounds. Experiment with all the sizes to find what works best for you. Good papers to draw on are HP 140# watercolor paper and Bristol smooth, heavyweight paper.

Line Widths of Black Pens with Permanent Ink

#1

08

05

03

01

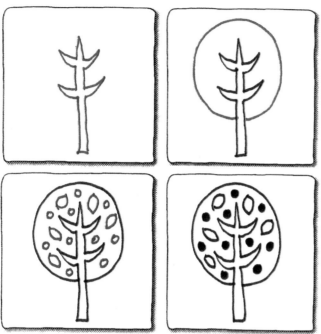

Tree. Draw a trunk with branches. Add a circle outline. Add small ovals and circles for leaves. (Featured on page 20.)

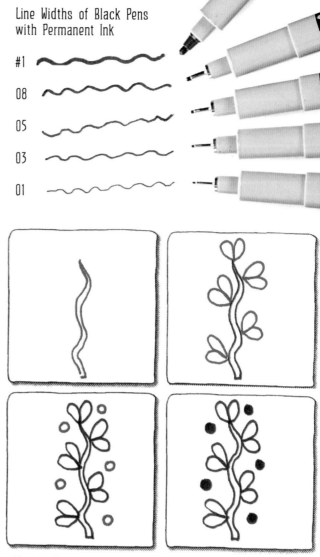

Fronds. Draw a stem. Draw pairs of leaves. Add floating circles for berries. (Featured on page 20.)

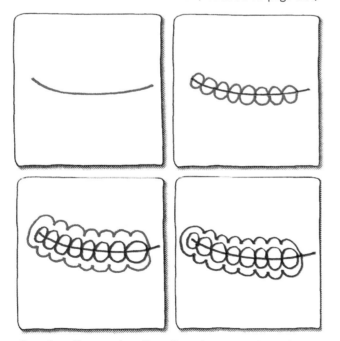

Branches. Draw a stem line. Draw bumps on both sides of the stem. Draw an outline around the bumps. (Featured on page 22.)

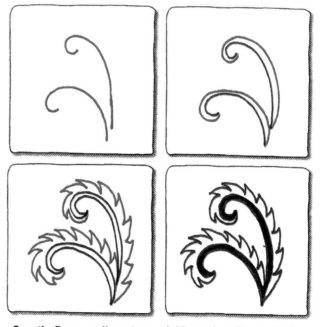

Growth. Draw curling stems. Add another line to each stem to make them wide. Add spiky leaves. (Featured on page 24.)

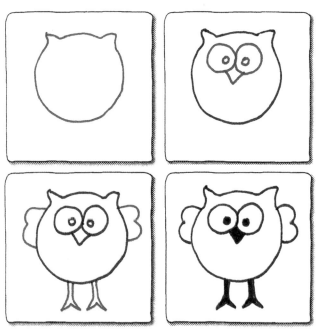

Owl. Draw a round body with ears. Add eyes and a beak. Add wings and feet. (Featured on page 17.)

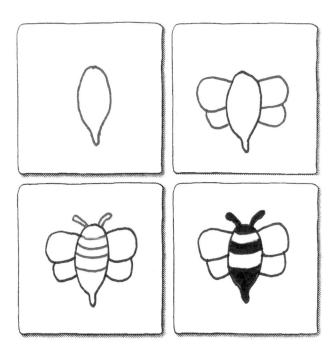

Bee. Draw a teardrop-shaped body. Add wings. Add stripes and antennae. (Featured on page 18.)

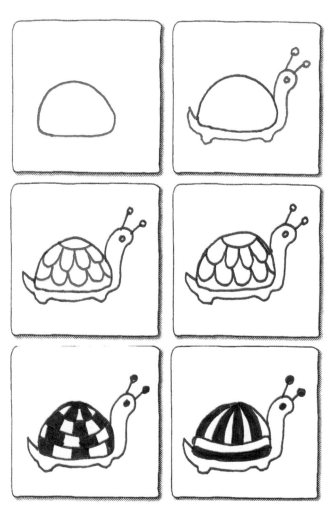

Snail. Draw a shell. Add a body, eye, and antennae. Draw a pattern on the shell and fill in the pattern if desired. You can create whatever shell pattern you like. (Featured on page 14.)

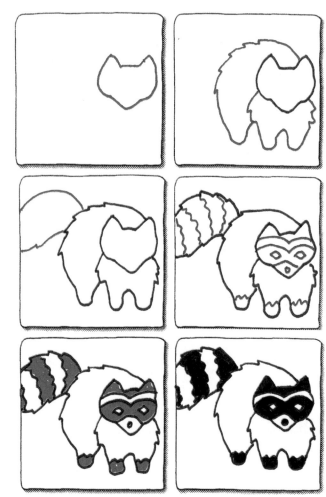

Raccoon. Draw a head. Add front feet and a body. Add a fluffy tail. Add fur, marking lines on the tail, face, and feet. Fill in sections with black ink. (Featured on page 8.)

DRAWING AND COLORING TIPS

You can start by tracing the woodland designs in this book if you want to get familiar with them. But soon, as you become more experienced, you'll learn to draw them freehand and customize them, making them fit your needs. Use real photos of flora and fauna as guides. Fill in the backgrounds of your drawings for a different effect. Add small details to give designs a finished, abundant look. Then add color. Color brings your art to life. Some of my favorite tools for adding color include Koi Coloring Brush Pens, Faber-Castell PITT Artist Pens, Prismacolor pencils, and watercolors applied with a soft round brush.

TRACE AND TRANSFER

Place tracing paper over the image and trace it. Turn the paper over and color the back using the side of a soft 2B pencil. Turn the paper over to the front and position it on your page. Trace the image and outline it with ink (an .03 MICRON works best).

BLACK BACKGROUNDS

Draw a design with ink. Add more designs and accents. Then outline around the designs with black ink. Fill in the background with black (an .08 MICRON or #1 Graphic pen works best).

TEXTURED OUTLINES

Experiment with a variety of lines to outline images to suggest waves, fur, hair, and spines.

ACCENTS

Draw small details in large background sections to add filler between the images of flora and fauna.

DETAIL PATTERNS

Add small patterns inside animal images and leaves to create texture and interest.

FILL PATTERNS

Create a shaded effect by adding dots, marks, circles, and patterns in the background.

2B PENCIL

Ink the outline. Lightly shade with pencil inside the image. Smudge the pencil with a tortillon (blending stump). Add pink in the ear and on the nose with a colored pencil. (Featured on page 8.)

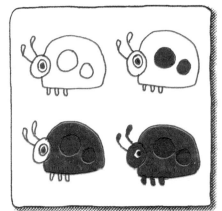

COLORED PENS OR MARKERS

Ink the outline. Color the spots black. Color the back red. Color the antennae, head, and legs black. (Featured on page 19.)

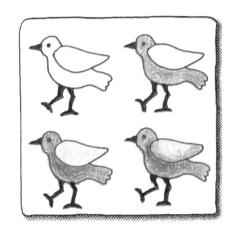

COLORED PENCILS

Ink the outline. Color the bird with a medium color. Color the wing with a light color. Add another layer of medium color along the bottom of the wing. (Featured on page 16.)

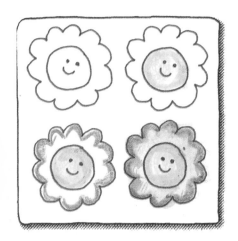

WATERCOLOR PENCILS

Ink the outline. Color the circle, then smudge the color with a waterbrush. Shade inside the border with color. Smudge the color with a waterbrush. (Featured on page 29.)

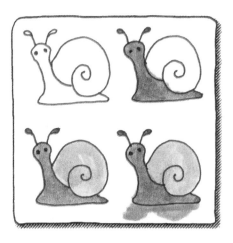

WATERCOLORS

Ink the outline. Use water, a brush, and watercolors to add color to the body. Add another color to the shell. Add a color shadow under the snail. (Featured on page 14.)

WATERCOLOR BACKGROUND

Ink the outline. Use a waterbrush and watercolors to add background color. Add a touch of color for a shadow at the leg and ear. Add another color to the inner ear. (Featured on page 10.)

CRITTERS

Here are some favorite critters in different poses. Be inspired to create your own masked raccoons, striped skunks, sleek weasels, happy hedgehogs, armored armadillos, silly squirrels, cheerful chipmunks, and prickly porcupines.

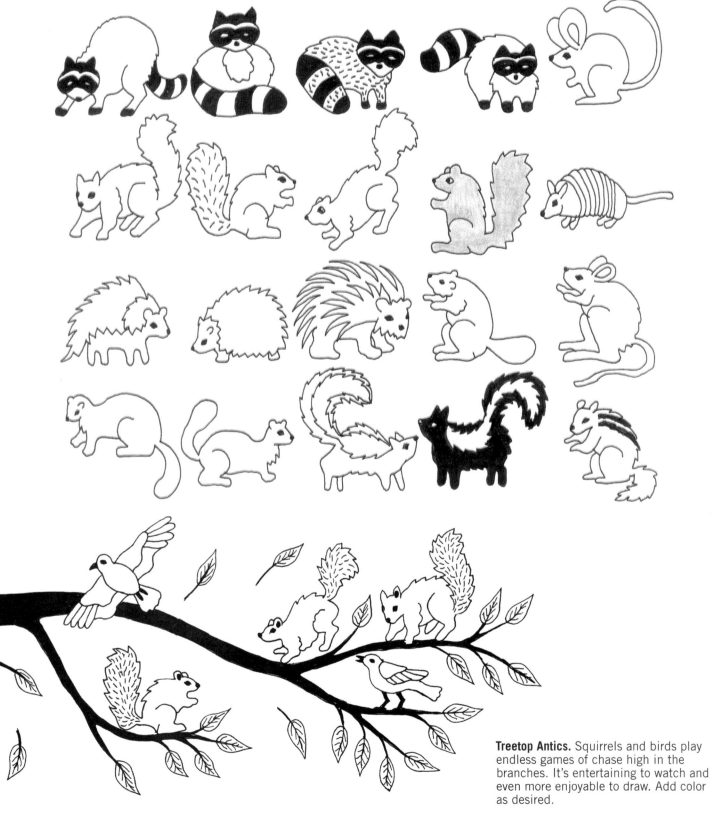

Treetop Antics. Squirrels and birds play endless games of chase high in the branches. It's entertaining to watch and even more enjoyable to draw. Add color as desired.

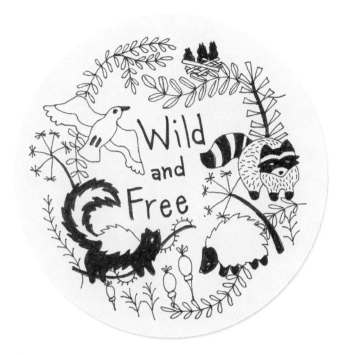

Wild and Free. Create a delightful mandala design with critters and greenery. Lightly draw a circle with a pencil. Draw critters, turning the paper as needed. Fill with stems and leaves to complete the circle. Erase the pencil line.

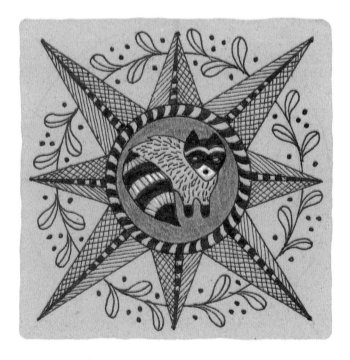

Masked Bandit. Showcase a raccoon in the center of an eight-point compass star. Use the corners and midpoints of a square to set the star points. Embellish a circle border with leaves and dots.

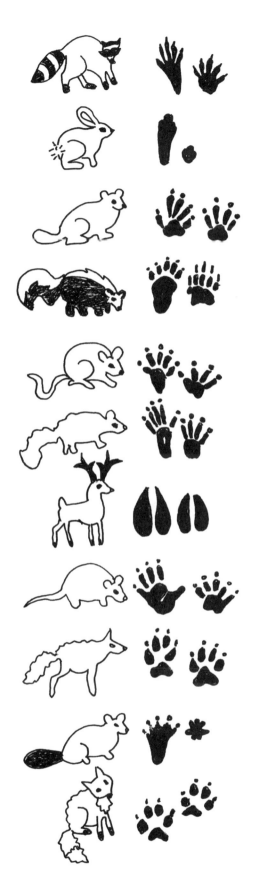

Footprints. Each animal has an identifiable footprint. Paw prints can add a bit of whimsy to any design.

BUNNIES AND FOXES

BUNNIES AND HARES

Cuddly and cute, bunny and hare antics are hilarious.
These designs will hop off the paper and into your heart.

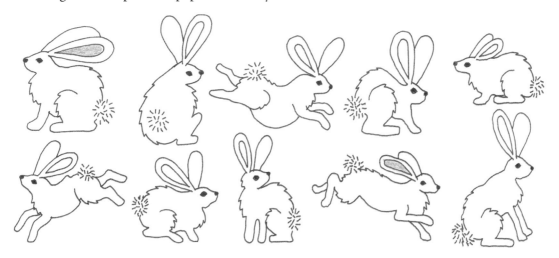

FOXES

Fluffy foxes frolic across a page in fabulous poses that will
make you smile as outlines emerge fluidly from an ink pen.

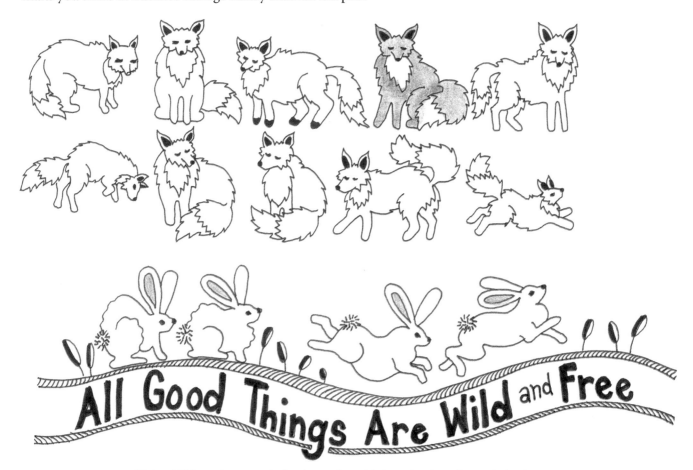

All Good Things. Create a design in motion with hopping bunnies and tiny leaves on a curving border. Write a saying between the lines with outlined letters.

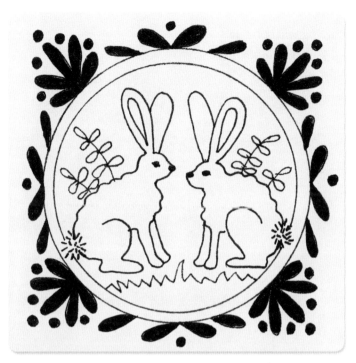

Bunny Buddies. Nothing says "I'm thinking of you" like hand-drawn art. This design is destined for someone you love. Draw a dual-circle border. Place two bunnies inside. Add accents and grass. Embellish the outer border.

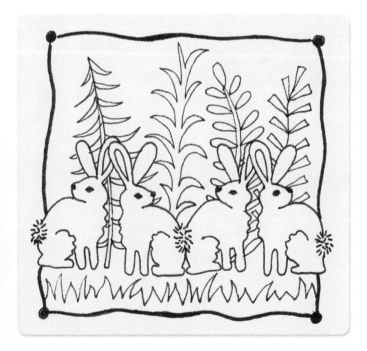

Four Bunnies. It seems like there's no such thing as just two rabbits. A group of bunnies is called a herd, and they live in an underground warren. Draw the bunnies, then add growth and spiky grass.

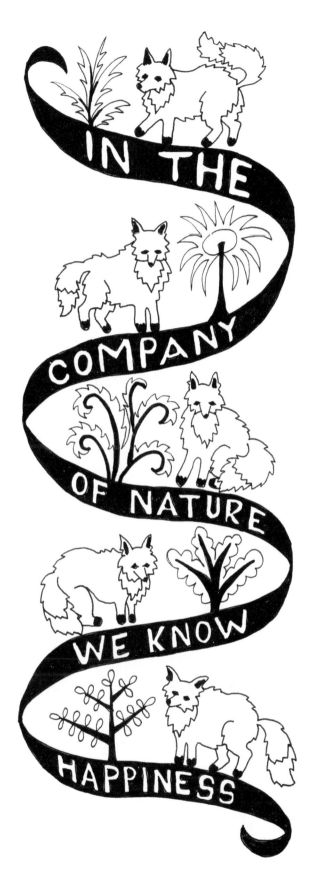

IN THE COMPANY OF NATURE WE KNOW HAPPINESS

In the Company of Nature. Create a ribbon border with pizazz! Fluffy foxes and plants enhance the message beautifully.

LARGE ANIMALS

Have you ever been intimidated by a blank white page? Try starting with one of these large animals. Add smaller shapes and filler accents until you are happy with the design. By drawing an animal large, it can be accented with patterns.

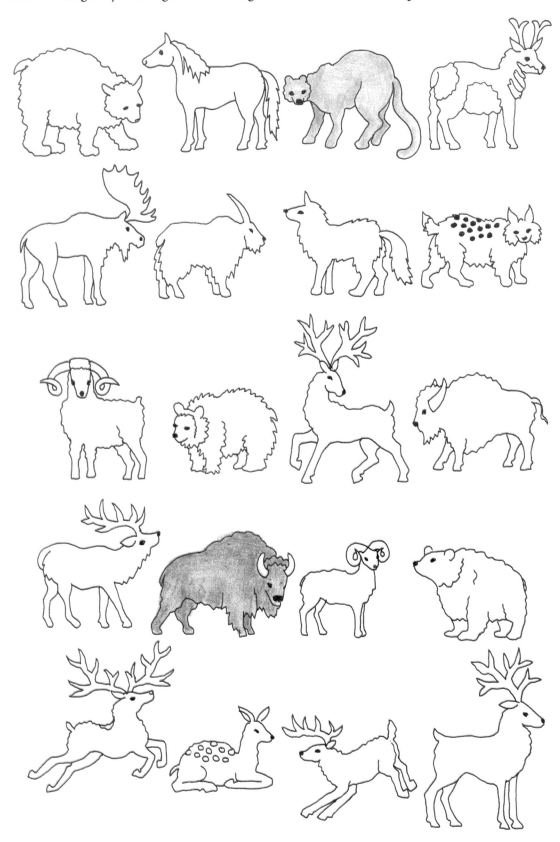

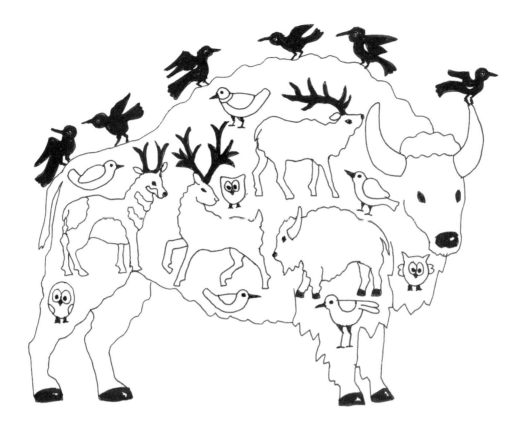

Buffalo Art. Go west, young artist! Scale up a buffalo to a larger size. Fill the interior with additional large animals and accents. Add birds to ride on its back. Draw it in a size to fit a picture frame so it can hang proudly in your home.

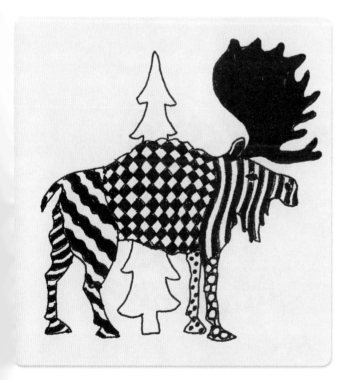

Patterned Moose. Capture the adventure of the great outdoors. Draw a moose. Add patterns inside.

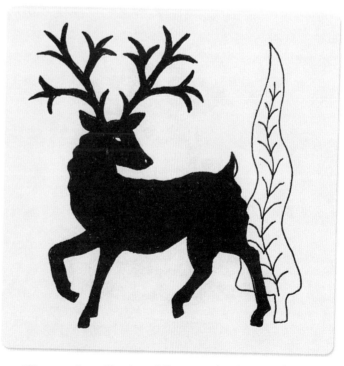

Silhouette Deer. Here's a different option for an animal. Draw a deer. Color the inside solid black.

POND DWELLERS

May your swimming hole be free of snakes and alligators—save them for art.
Nature thrives in rivers, lakes, and ponds. Use this abundance of fish, frogs,
and other creatures to enhance your designs.

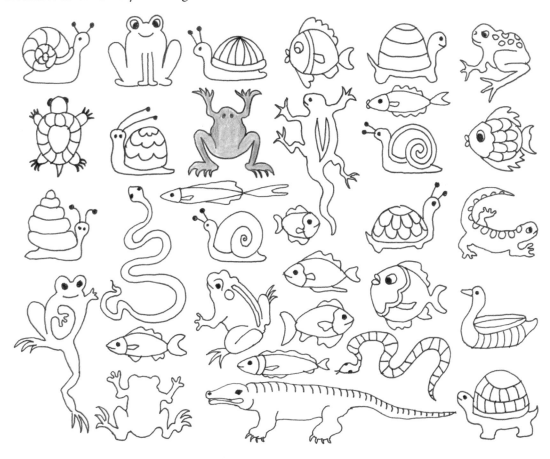

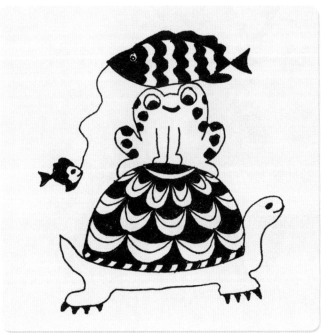

Turtle Taxi. Pure whimsy with a dash of imagination: a turtle
gives a ride to a frog and a fish. Break from the conventional
and ignite your creativity.

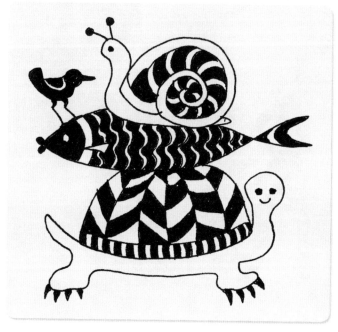

Traveling Tortoise. A fish, a bird, and a snail hitch a ride on a
tortoise... for a comical design. Be mischievous, be daring.
Draw something that happens in your imagination.

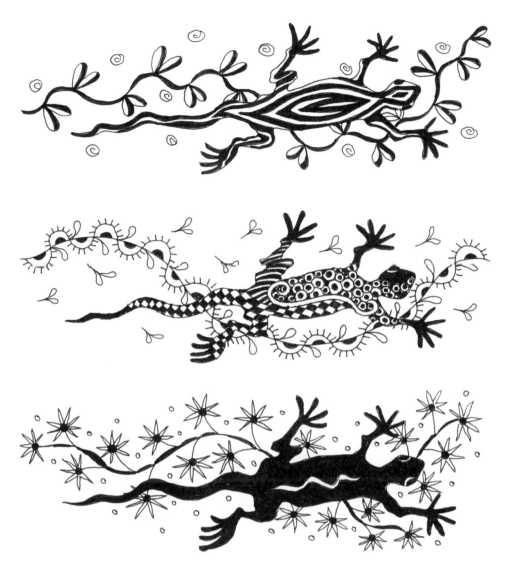

Gecko Variations. Any of these gecko designs would fit perfectly on a bookmark and make a wonderful gift for a friend or family member. Use a black .03 MICRON pen to outline the gecko, draw patterns, and add the background. For the tree bark gecko, decorate a gecko with a bark design. For the patterned gecko, go wild with many different patterns. For the chameleon gecko, make the gecko similar to the background so that it blends in.

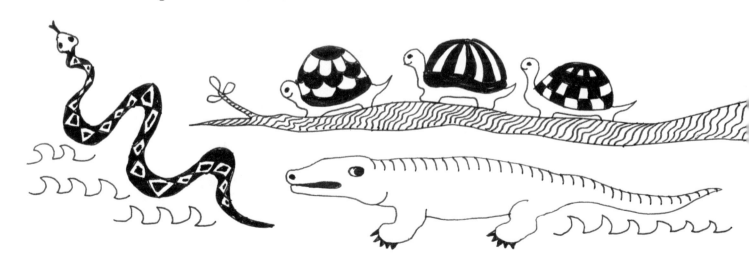

On the Move. It's so easy to draw a snake—don't run away screaming! Most snakes are beneficial, and they are pretty when you look closely. Relax your hand and create a smoothly curving line.

BIRDS AND OWLS

BIRDS OF A FEATHER

Birdsong brings a forest to life. It soothes the senses and alerts us to the wonders all around. Using simple outline shapes, fill a page with an abundance of birds.

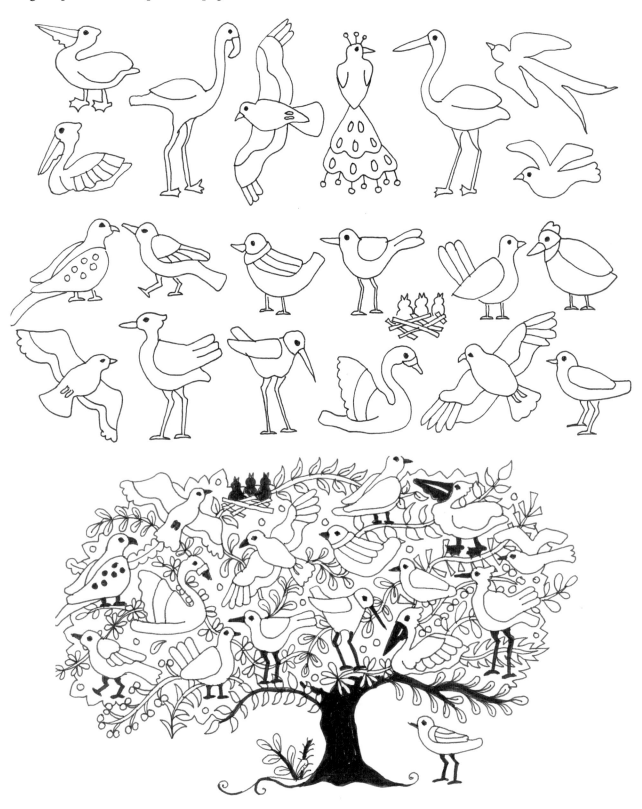

Tree of Birds. How many different birds can be found nesting in this tree? Begin this project with the trunk. Then outline the birds. Finally, fill the tree with branches and accents.

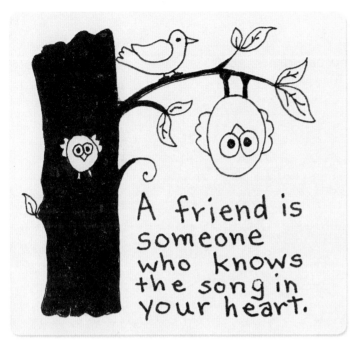

A Friend. Birds come in all shapes and sizes. Draw a tree and branch, then add birds and words.

WISE OWLS

Owls have been a symbol of wisdom since the Ancient Greeks, so it's no surprise that the owl continues to be a popular motif. You'll find an abundant "parliament" of owl styles in this collection. Experiment with the eyes—some are small and some wide open.

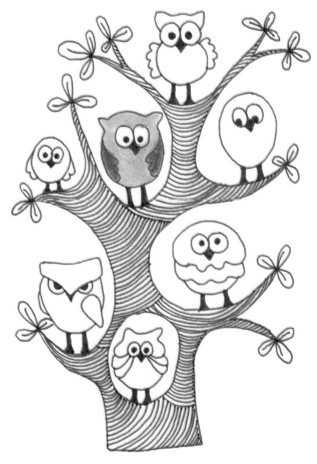

Owlery Tree. Give a hoot for this design. Draw a whimsical tree with curly spaces. Place an owl in each space.

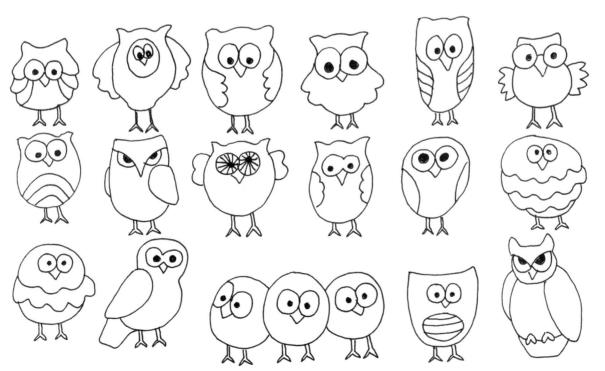

INSECTS AND SPIDERS

BEETLES, SPIDERS, AND MORE

Bugs are responsible for maintaining our soil, so they are a very important part of the ecosystem. They are also colorful and interesting. They definitely deserve a place in woodland art.

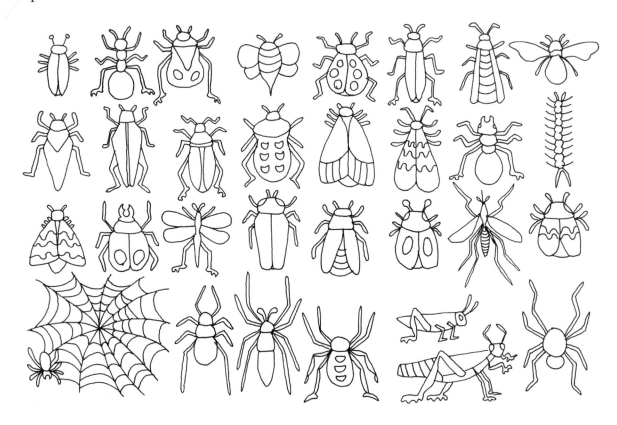

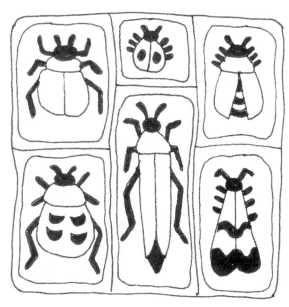

Botanical Bugs. Draw some rectangles on a page. Fill them with bug drawings just like you would find in one of those old botany books.

Bugs on Words. Use old book pages as the background for drawings. Text paper gives your art a completely different look, and text is really stylish.

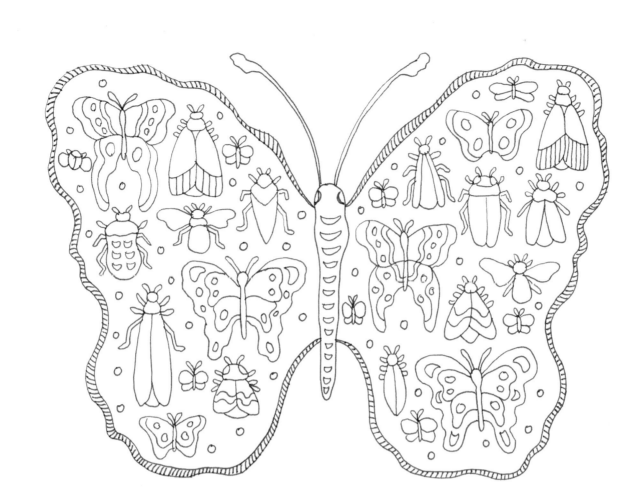

Wonderful Wings. What a great way to display bug designs! Start with a large butterfly. Embellish the body with a pattern. Fill the wings with bug images. Add circle accents in the spaces.

BUTTERFLIES, CATERPILLARS, AND MORE

Colorful wings and interesting body shapes add to the visual variety of insects. When drawing bugs and butterflies, feel free to experiment with the wing and leg shapes. Some wings are oval, some have patterns, some are elongated, and some are swallowtails. Remember, drawings don't have to be "real" or accurate. Make your drawings as fanciful and colorful as you want.

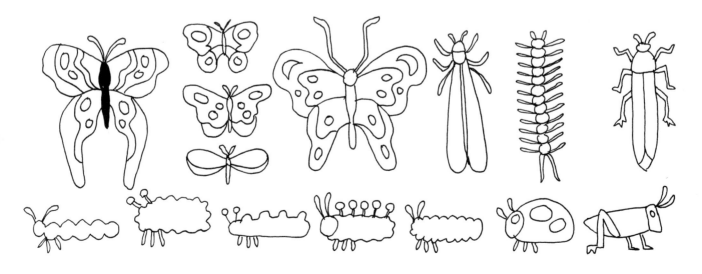

TREES AND FRONDS

Nature has blessed our planet with an abundance of trees—over 23,000 beautiful species. Fortunately, basic tree shapes are easy to draw. Use these samples as inspiration to create an entire forest.

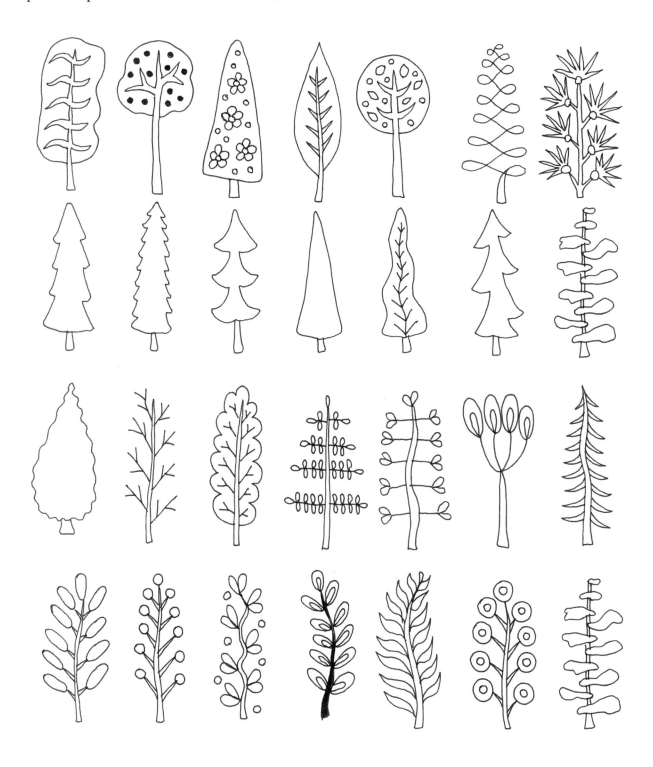

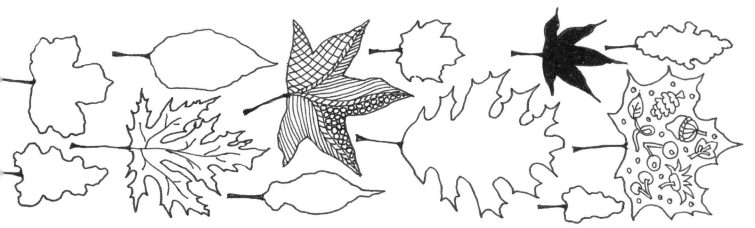

Leaf Outlines. Fill an open leaf shape with patterns or veins for a wonderful effect, or place a bug inside a leaf. For more inspiration, go for a walk in a park to collect leaves. Trace around them.

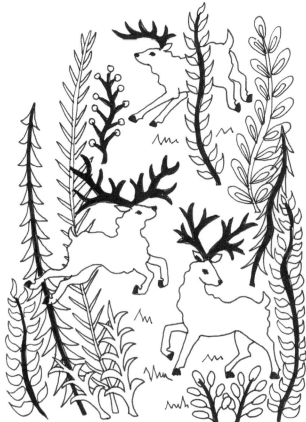

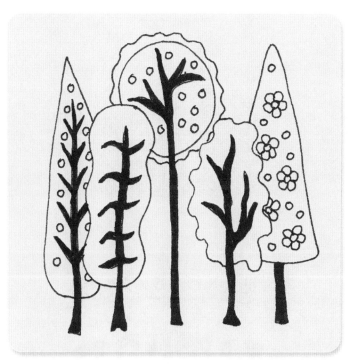

Prancing Deer. Coming across deer in a forest is an unforgettable experience. These creatures have amazing grace, beauty, and speed. To place deer in the foreground, draw the deer first. For a hidden deer, draw the fronds first.

Forest of Trees. Use an .03 MICRON pen to draw each trunk shape. Then enclose the branches with a rough triangle, oval, or circle. Add some small circles for leaves or accent the trees with flower shapes.

"Let's take our hearts for a walk in the woods and listen to the magic whispers of old trees."

A WALK IN THE WOODLANDS

A walk in the woods refreshes the spirit, awakens senses, and invigorates creativity. Undergrowth crunches beneath your shoes. Birdsong presents a symphony while leaves rustle in time with the breeze. Buds burst to life, perfuming the air, attracting buzzing bees and colorful butterflies. Like great trees drawing water from the depths and up to their leaves, the thrum of life rises through your feet, filling your spirit with energy and joy.

"If you truly love Nature, you will find beauty everywhere." (Vincent van Gogh)

BRANCHES AND LAURELS

BRANCHES

Simple branches drawn in true-to-life fashion resemble a botanical diagram.
Or create a whimsical interpretation of your own. Possibilities become
limitless when you mix your imagination with leaf designs.

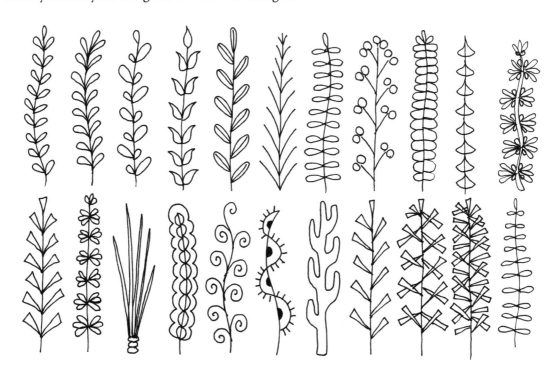

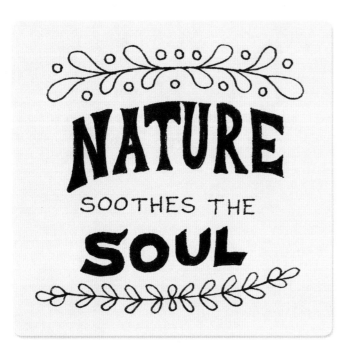

Nature Soothes the Soul. Indeed it does. That's why
soundtracks from the forest are played at the spa. That's
why gardeners love their gardens. When nature and art are
combined, you are doubly blessed.

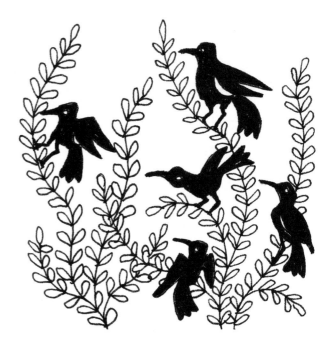

Birds in the Bush. Curious birds are on the lookout for
something. Maybe they are watching as the bird feeder is
filled again. Their poses are alert—they are ready to fly. Start
this design with a light pencil line to rough in the position of
the branches. Then use an .03 MICRON pen to draw the birds.
Add portions of the branches that are behind the birds. Ink
over all the pencil lines.

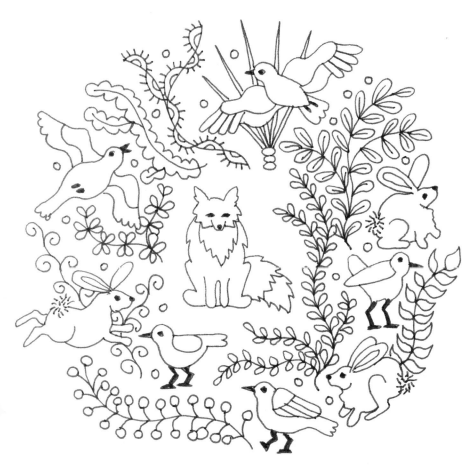

Circle of Life. The fox takes center stage, observing like a king all of the doings of bunnies and birds. Draw a large circle and an inner circle lightly with a pencil. Draw a fox in the center. Draw animals around the circle, turning the paper as needed. Fill the empty spaces with branches and add tiny circle accents.

LAURELS AND BANNERS

Laurels are often ovals trimmed with leaves. Use them to frame words or separate areas of your art. Banners display messages. Their curling lines draw the eye to words.

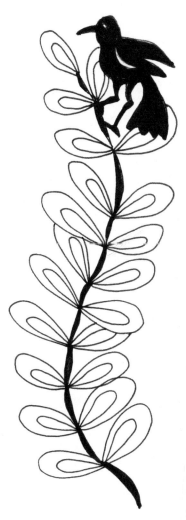

Bird on a Branch. A curious bird observes his surroundings. Is he looking for food or just enjoying the sunshine?

GROWTH AND SEEDS

BUSHES AND GROWTH

Growth is the source of abundance in the forest. Tiny shoots become tall plants; tendrils sprout leaves and entwine around everything that stands still. As you draw your forest, include some buds and leafy bits.

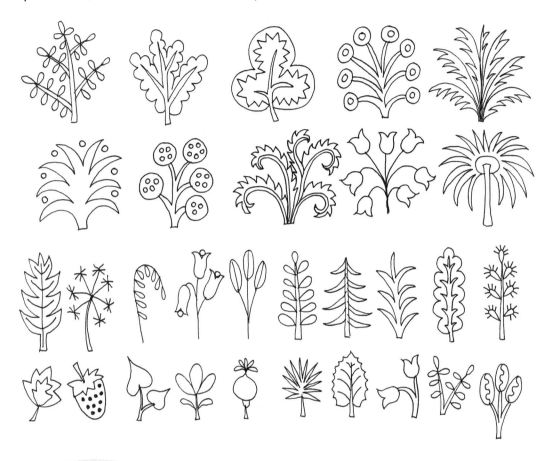

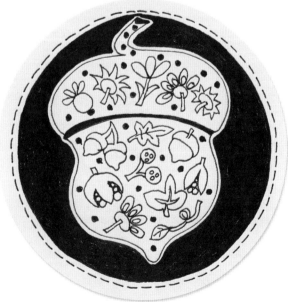

Tiny Acorns. A large acorn filled with images of growth! The acorn is a symbol for growth and the source of the mighty oak tree.

"We are all butterflies. Earth is our chrysalis." (Lee Ann Taylor)

A COMPLETE ROSE

Imagine a long-stemmed rose. Picture it firmly in your mind: the dark green woody stem, the prickly brownish thorns, the flower in bloom. Something is missing. Yes, it's the buds. Plants just aren't complete without them. The same is true for your art. Next time you feel a space is missing something, add some buds.

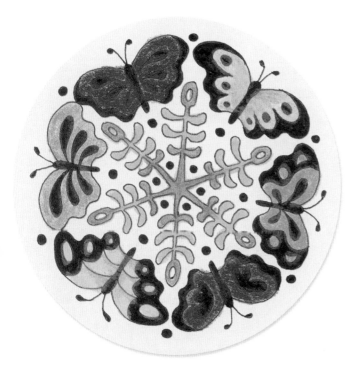

Butterfly Mandala. Divide a circle into six parts with a pencil. Draw six butterflies around the circle, turning the paper as you go. Notice the wings on the butterflies are all different. Draw center branches, then add little circle accents.

SEEDS AND PODS

Tiny treasures wait inside each pod, nut, and berry!

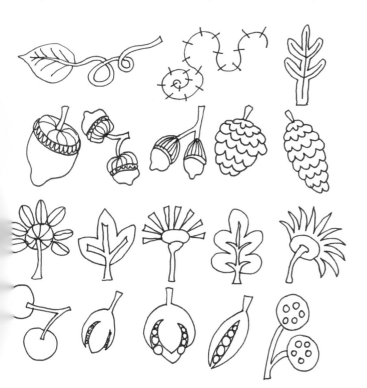

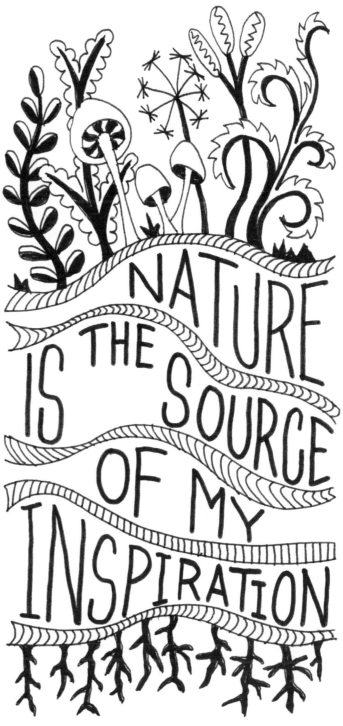

Nature is the Source. Next time you want to draw something but can't decide what, grab your sketchbook and go to the botanical gardens or walk through the park. Visit a pond or stream. Spend a few moments taking in the sunshine. Or take in the stars—nature doesn't shut down at sunset! Some flowers only release their perfume at night and some birds sing in moonlight. You can find inspiration at any time of day.

MUSHROOMS AND ROOTS

MUSHROOMS

Interesting shapes and colors abound in the world of mushrooms. Draw some with long stems, some with short. Some caps are narrow and tall. Others are wide and bowl-shaped. Introduce a variety in your art.

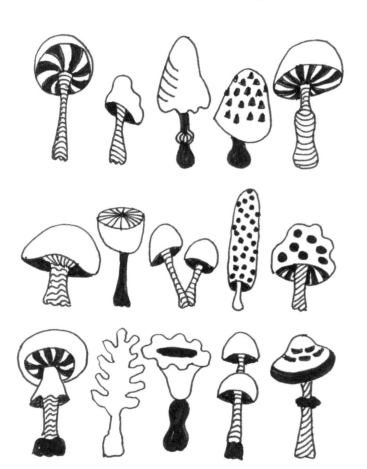

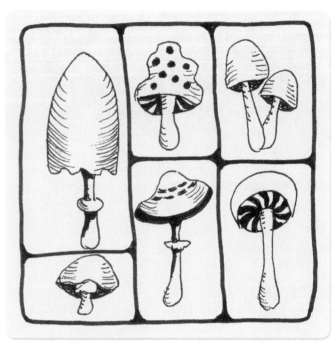

Mushroom Collection. Collect a few interesting mushroom images.

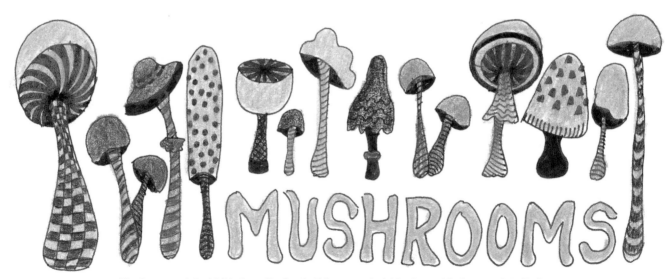

Mushrooms. A hobbit's favorite food. If I were a hobbit, I would share a detailed account of the names and cooking method for every mushroom. However, being human, I would rather draw them.

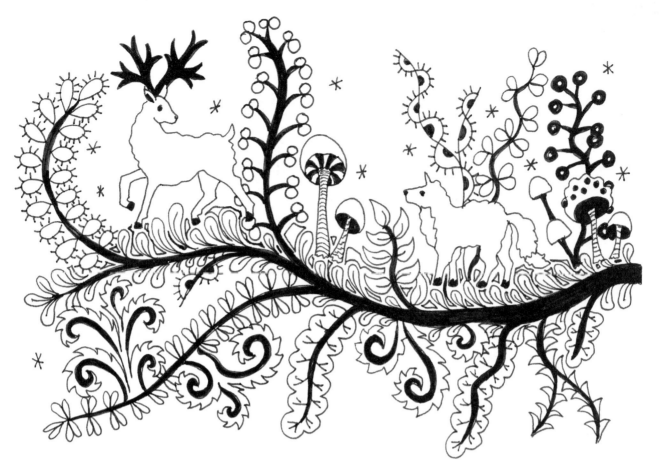

Branch Border. Simply gorgeous growth! The plant shapes draw you into a fairytale environment where the deer and coyote communicate and become friends. It's a magical place that is born of creativity and imagination.

ROOTS

Roots are essential parts of a plant, bringing nutrients up from the ground.

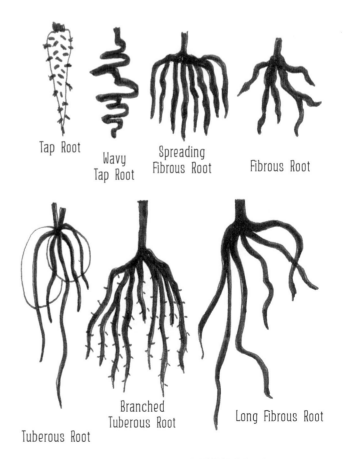

Tap Root

Wavy Tap Root

Spreading Fibrous Root

Fibrous Root

Tuberous Root

Branched Tuberous Root

Long Fibrous Root

Floral Mandala. This circle feels like sunshine. The center radiates vibrant life out to the edges through roots and buds. Begin at the center and work outward.

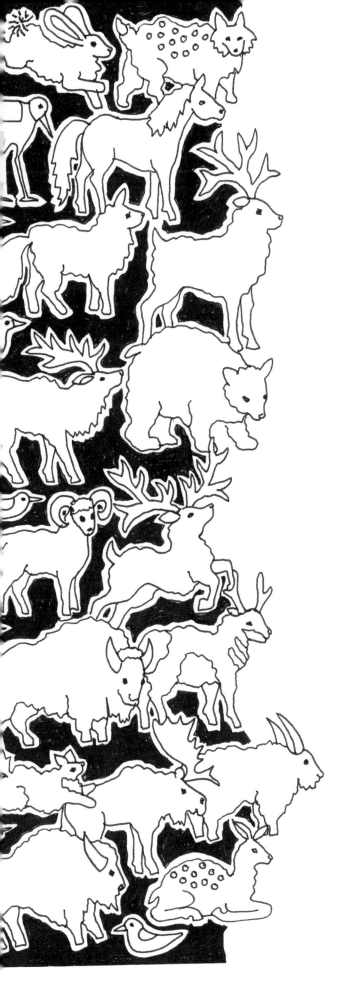

LANDSCAPES AND WEATHER

LANDSCAPES

A forest is more than trees and flowers and critters. It's sky and mountains, hills and terrain, bushes and waves, ground and grass. Nature is a total ecosystem. Here are some shapes that will help bring focus and definition when they are added to woodland art.

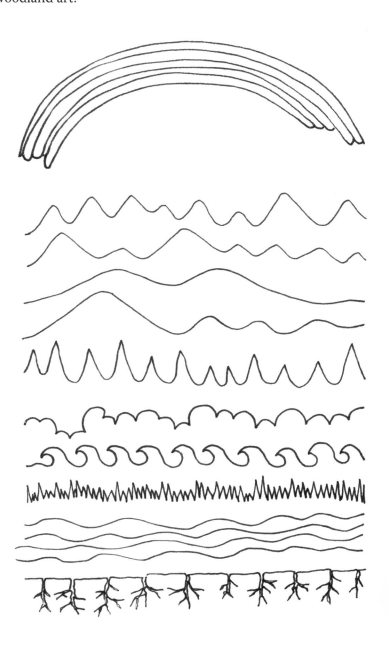

Wildlife Border. Fill a vertical or horizontal border space with big animals. Outline the background sections with black. Fill in the background with black (an .08 MICRON or #1 Graphic pen works best).

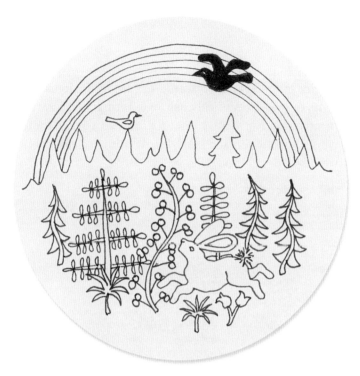

Rejoice. A bunny jumps for joy upon catching sight of a rainbow. His forest, replenished and sparkling with recent rain, sings of life.

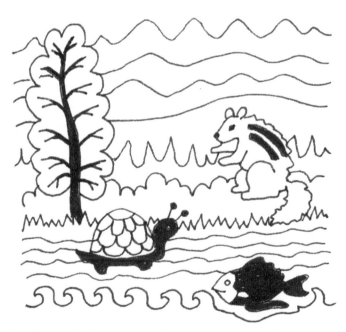

The Riverbank. This is an idyllic scene, perfect for hanging in an office or as a birthday card. This landscape setting breathes serenity and calm. Oh, what wonderful feelings art can evoke!

WEATHER

Clouds bring rain, rain replenishes streams, streams pour into oceans, and sunshine evaporates oceans into clouds again. The atmospheric cycle keeps the planet alive. Celebrate this miracle with simple images.

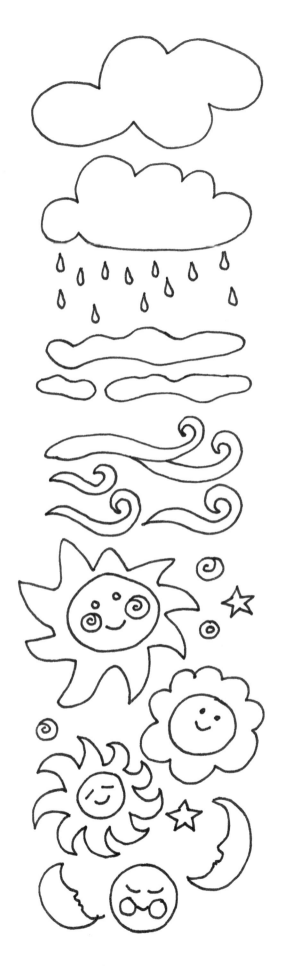

EMBELLISHED ALPHABETS

Important documents all through history, such as the Bible and royal wedding invitations, have been graced with embellished alphabets. Handwritten notes are so rare these days that they are becoming treasures, especially when you take the time to create fancy lettering. Everyone likes to see their initials, monogram, or name drawn beautifully, especially when it is embellished with fun accents. Decorate, embellish, outline, and expand a printout of computer alphabet fonts to create beautiful custom lettering. Start by printing your favorite computer font (an outline font works best). Then add owls, birds, animals, leaves, or whatever details you'd like.

Owl Alphabet. Convey a lighthearted message with clever hand-drawn owls peeking around the letters in a variety of poses. (Font used: Papyrus, Outline)

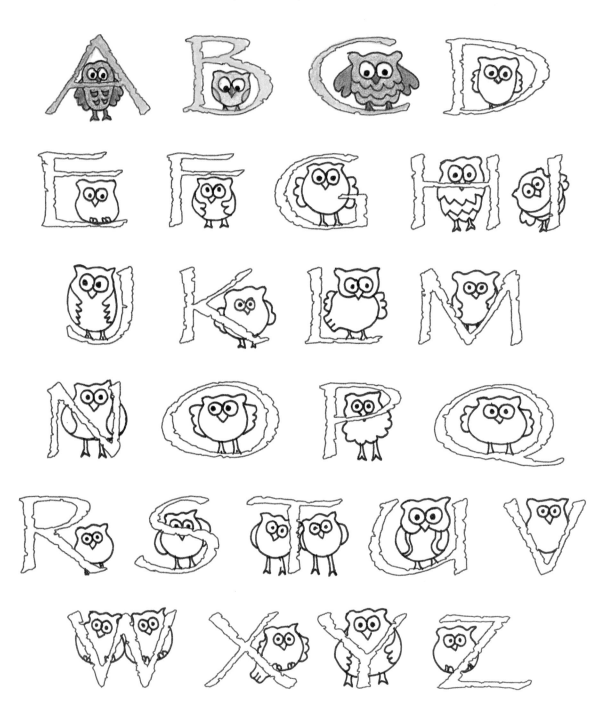

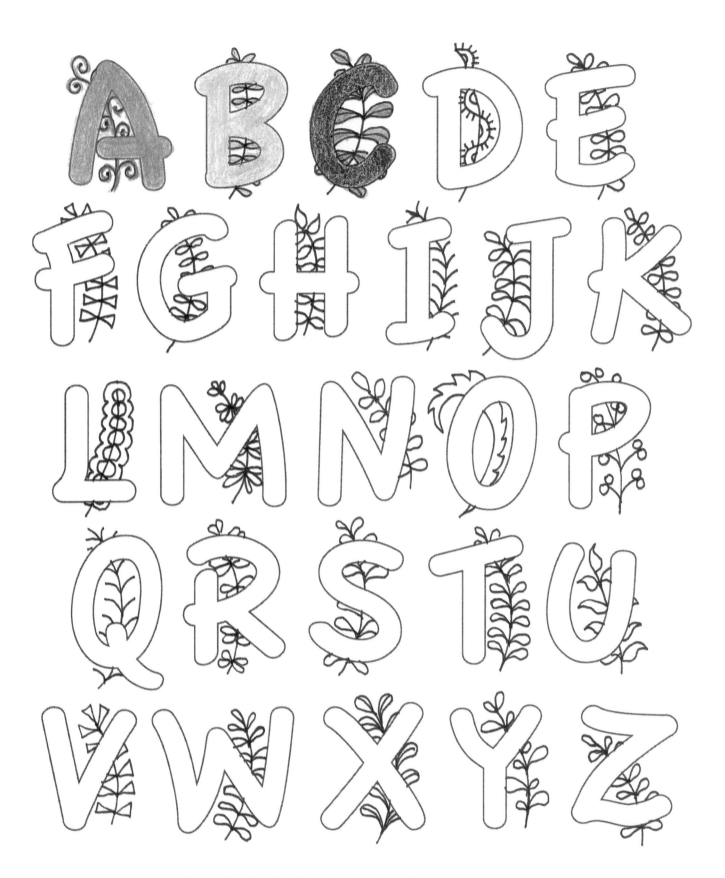

Forest Alphabet. Bubble letters have been fun ever since we learned to draw them in grade school. Enhance letters with leafy fronds and branches. (Font used: Apple Casual, Outline)

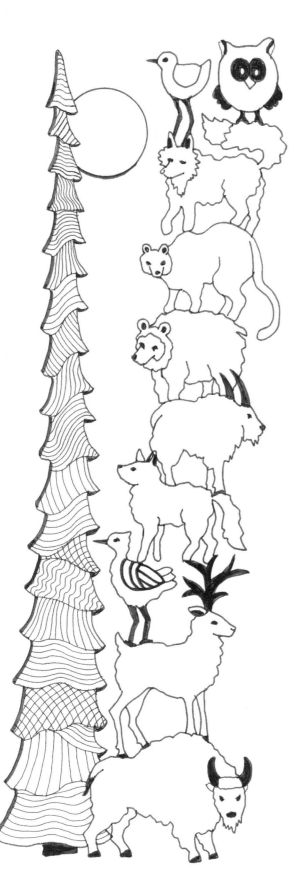

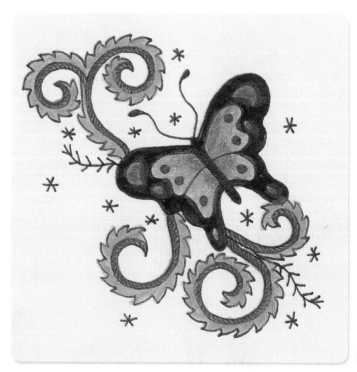

Mystical Butterfly. Swirling branches set the background in motion for this lovely butterfly. "I embrace emerging experience. I participate in discovery. I am a butterfly." (William Stafford)

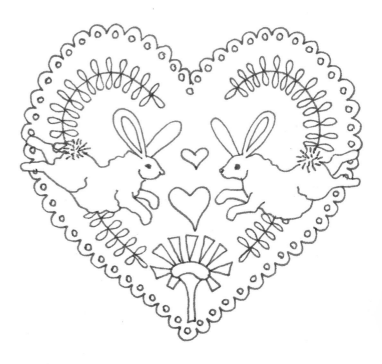

Tower of Animals. Stacking figures has become a popular technique in many art forms. It's fun to see how the shapes go together, like creating a vertical puzzle. The tall tree and moon set the stage for nighttime antics in the forest.

Bunny Love. The love of bunnies is a year-round affair, so this artwork will be on display long after Valentine's Day or Easter. Use a pencil to draw a heart shape. Draw the bunnies, then draw accents around the heart.

FLORABUNDA WOODLAND
WORKBOOK

Welcome to the *FloraBunda Woodland* workbook section! This workbook is meant to be your space to explore the FloraBunda designs and enjoy letting them flow from your pen. Open your imagination and let the prompts and ideas inspire your creative spirit. You'll see delightful ways to draw interesting critters, trees, mushrooms, and more. Take this book outside to sketch—nature itself is an endless source of inspiration. With more than 300 patterns to choose from, you can mix and match combinations so you never run out of exciting possibilities.

These pages have a lot of space on them because you'll need it to let your creativity flow. Don't feel limited by what's on the page, either—you don't have to follow the exercises if you have ideas of your own! This is your place to play, experiment, and create.

So go ahead, draw a forest, add some squirrels, toss in some shrubs, and design a stunning sky. Let the organic lines of FloraBunda inspire you, and have fun.

HAPPY DRAWING!

DRAW-IT-YOURSELF DESIGNS

This exercise shows you just how simple it really is to draw even seemingly complicated designs. Each design is broken down into several straightforward steps that you can follow to build the completed design quickly and easily. Practice the steps in the squares provided, and learn to see the component parts in each design.

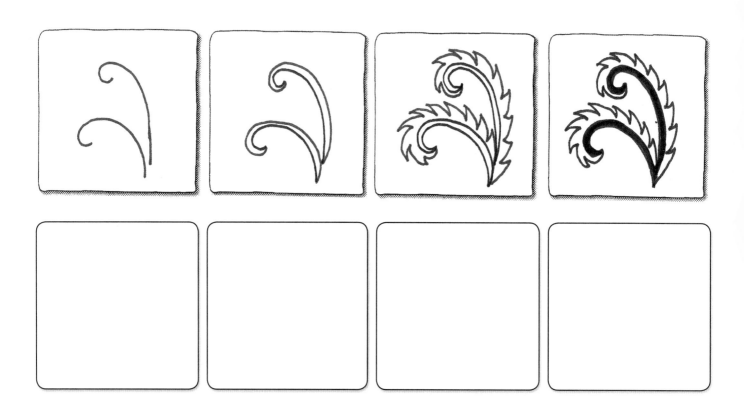

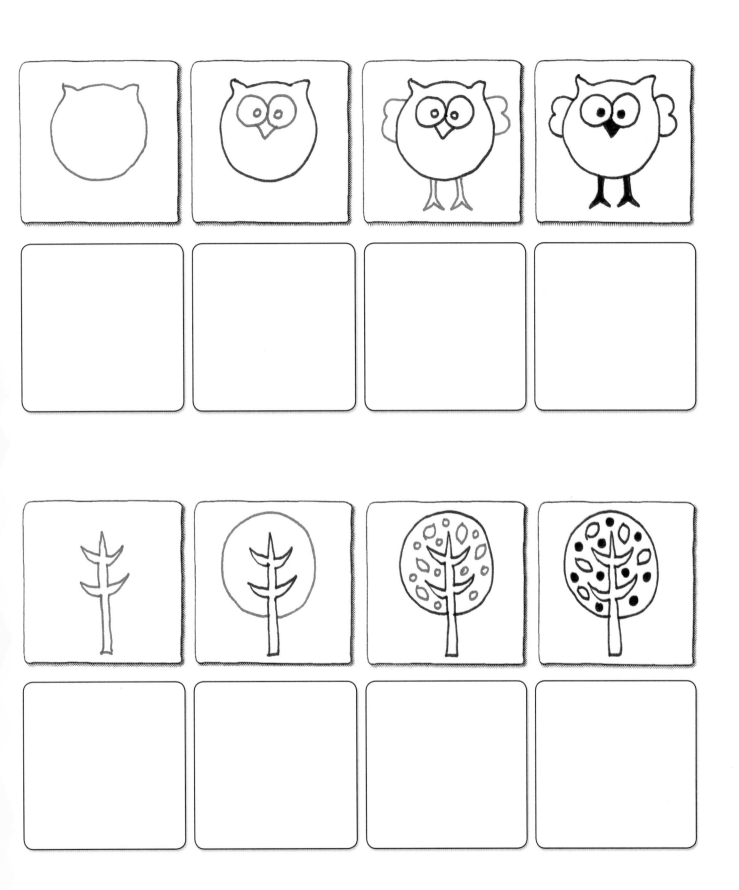

ADD SHADING

Color is not the only way you can enhance your FloraBunda compositions! Take a look at the shaded samples on these pages and then try your hand at adding depth and dimension to the art yourself. Your designs will look all the more artistic!

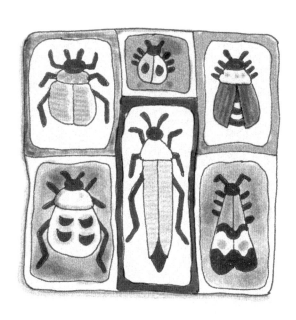 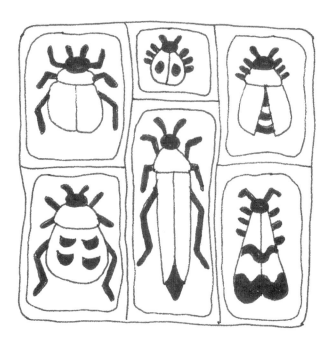

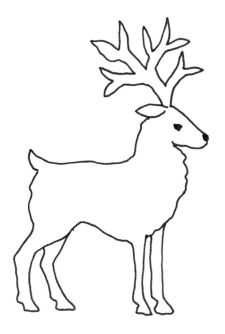 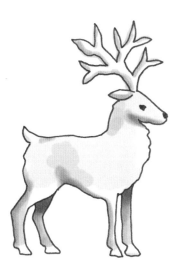

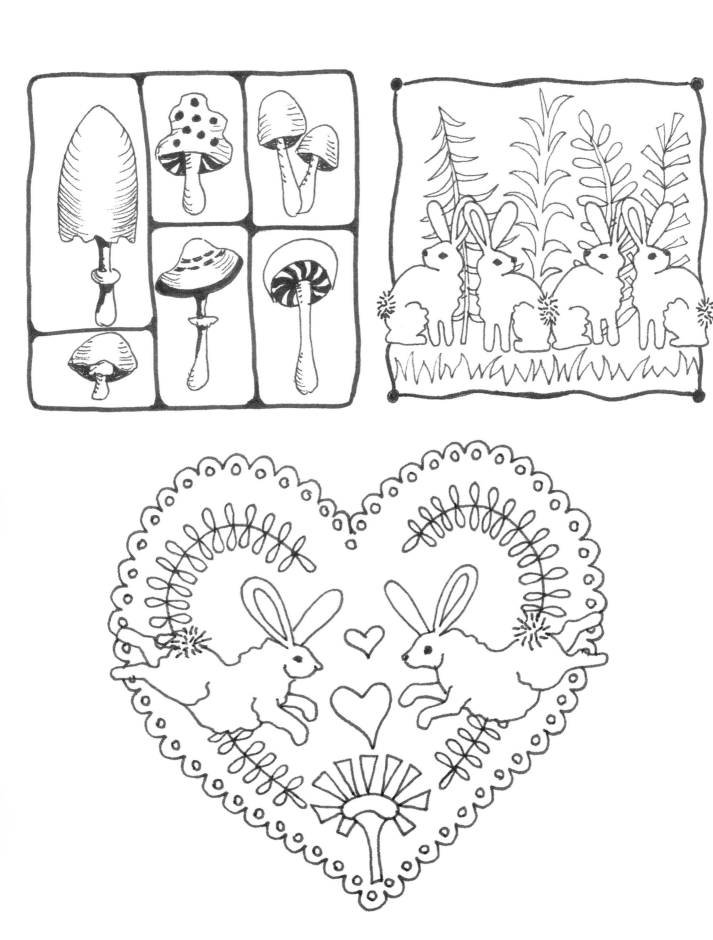

EMBELLISH QUOTES & MORE

On these pages you'll find some great, inspiring quotes and shapes already designed and just waiting for woodland embellishment. Stick to one species like the sample shown, or feature a whole world of animals; embellish with just one style of leaf or use them all! It's totally up to you.

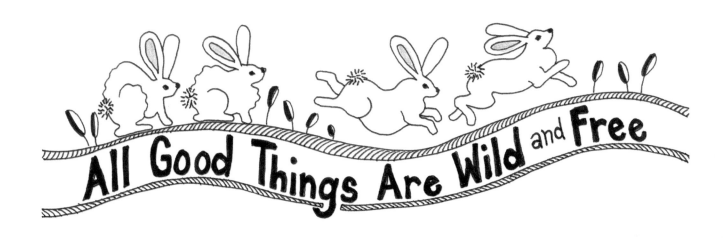

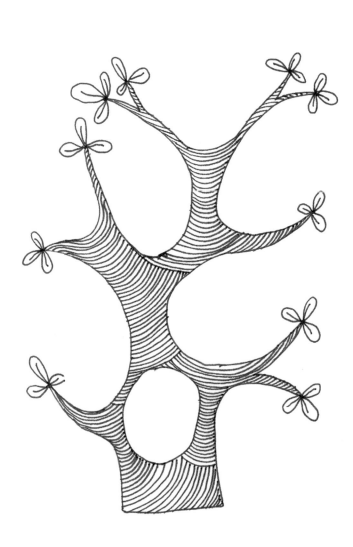

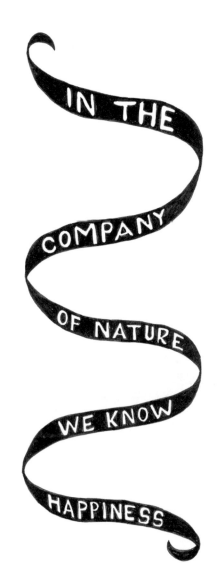

IN THE COMPANY OF NATURE WE KNOW HAPPINESS

NATURE IS WORTH MORE THAN KNOWLEDGE

FILL A FOREST

It's time to populate this sparse forest with abundant woodland flora and fauna! Give some critters a home in the branches of trees, set fish and frogs swimming in the pond, and add birds flying on the wind currents in the sky. Let a fantasy forest come to life on these pages.

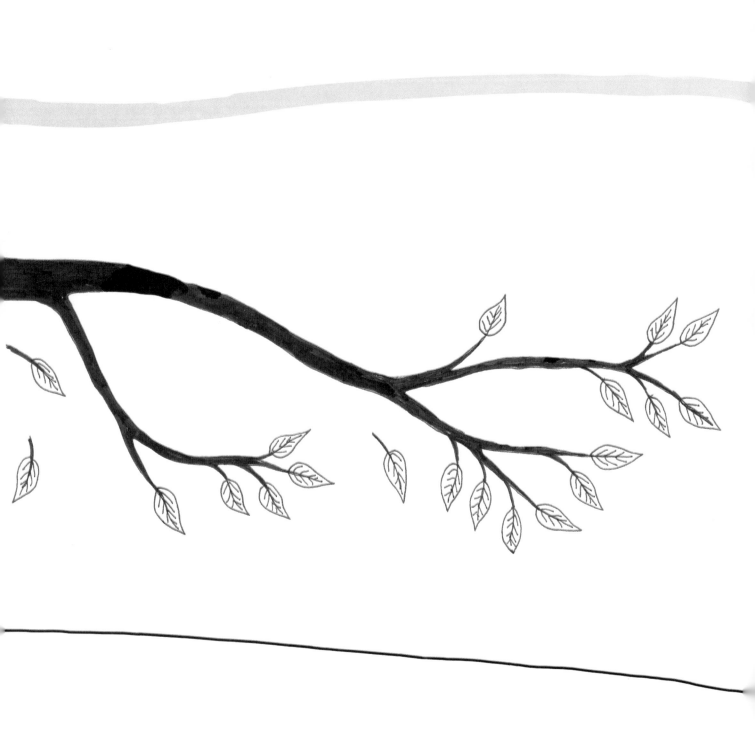

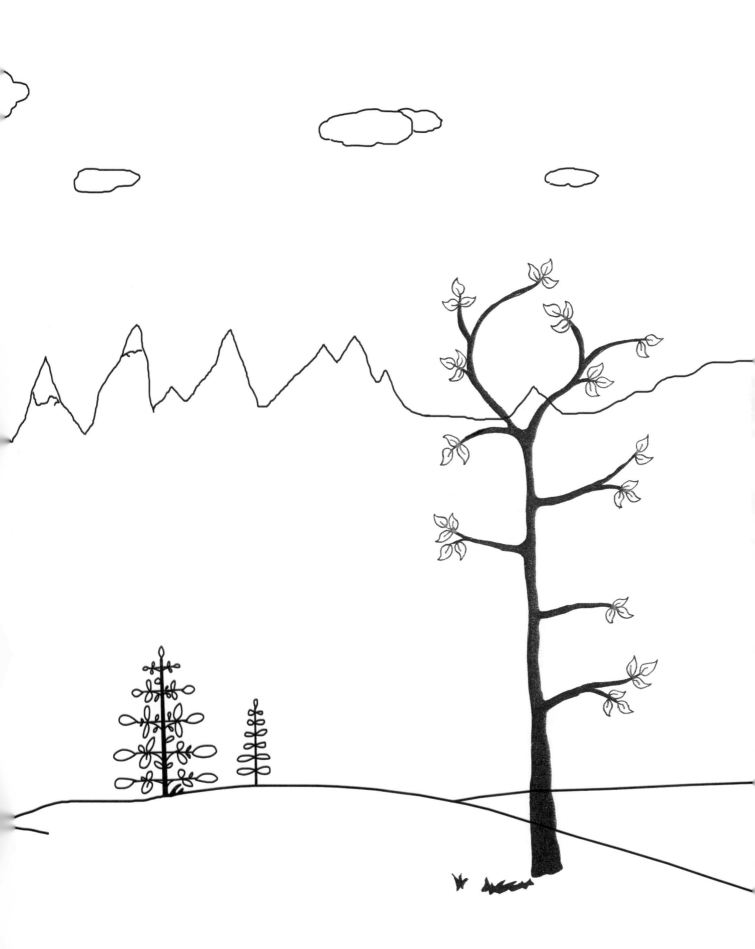

MAKE YOUR OWN MANDALA

Throughout this book you'll see designs worked into circular mandala shapes. Mandalas are often symmetrical, sometimes dense or sparse, and always beautiful. Use the basic mandala outlines here as jumping-off points for your own new creations.

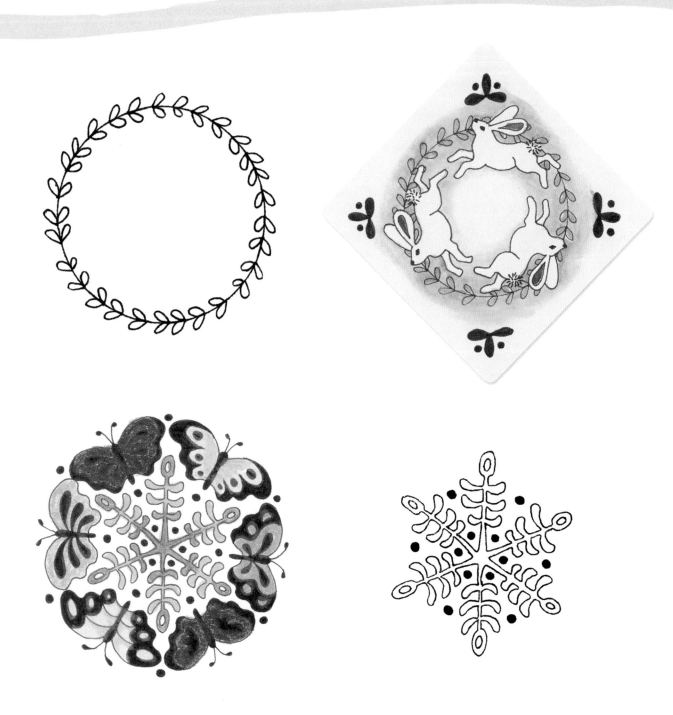

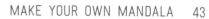

ADD COLOR

Just feel like relaxing? Instead of creating your own composition, just color some of these pieces and get inspired! Try colored pencils, crayons, or markers. Or get really creative and use fun tools like gel pens and watercolor pencils. This is your space to transform black and white designs into glorious color.

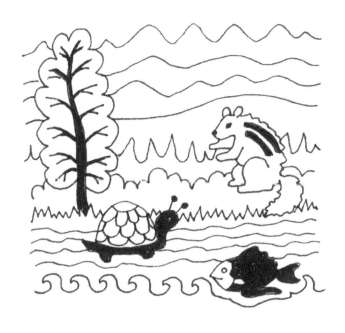

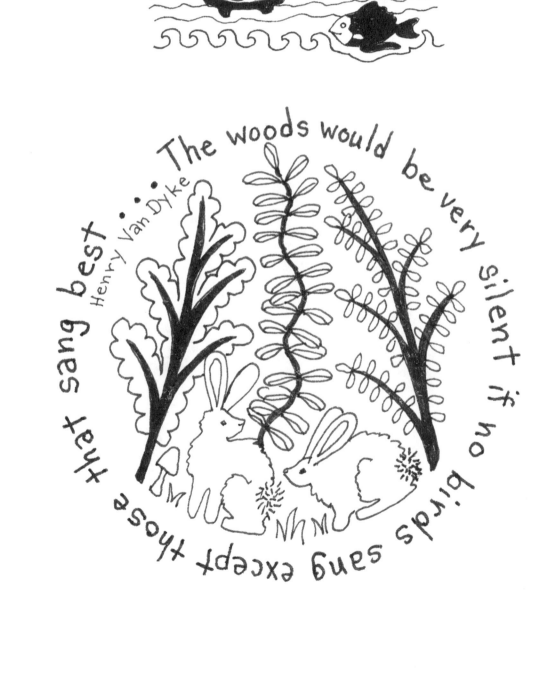

The woods would be very silent if no birds sang except those that sang best

Henry Van Dyke

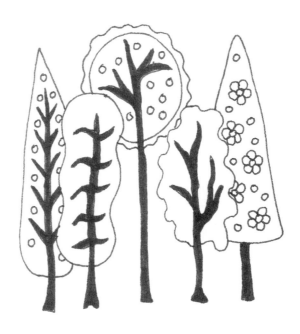

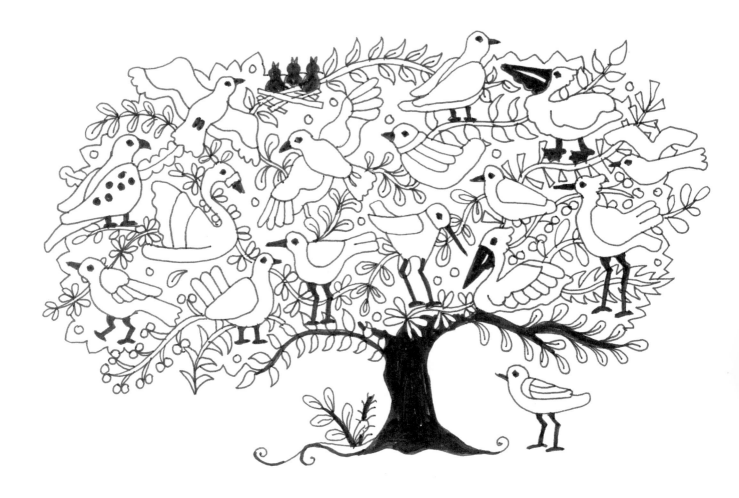

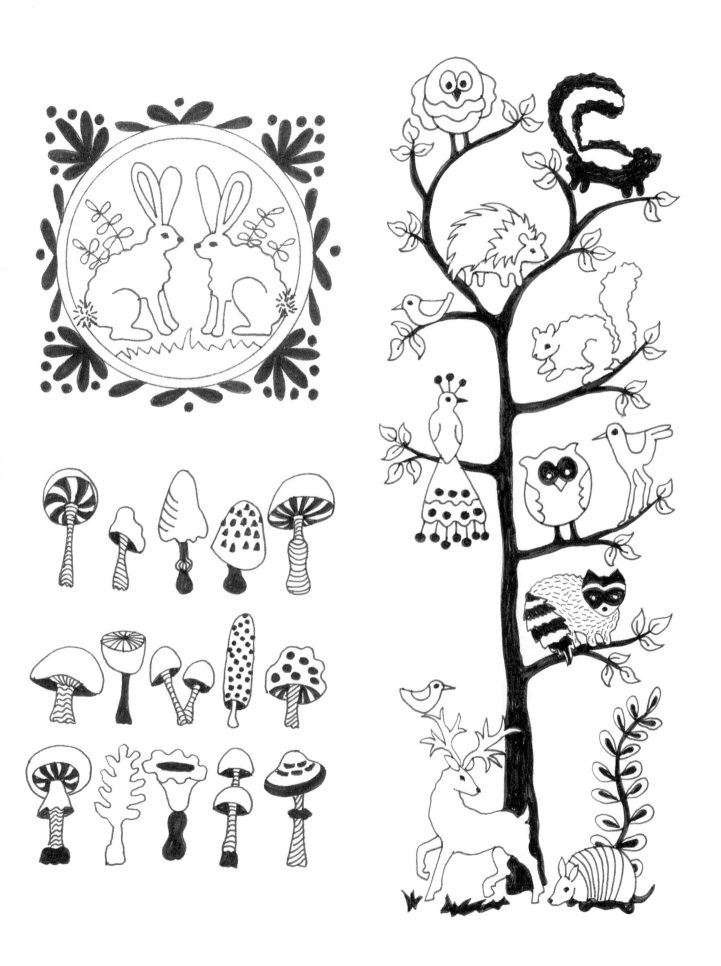

FLORABUNDA WOODLAND DESIGN
INDEX OF 300+ PATTERNS

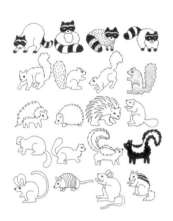

Critters pages 8–9

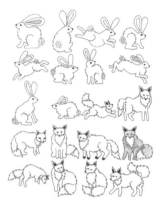

Bunnies and Foxes
pages 10–11

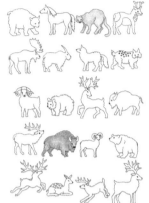

Large Animals
pages 12–13

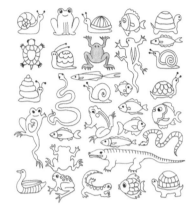

Pond Dwellers
pages 14–15

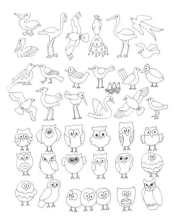

Birds and Owls
pages 16–17

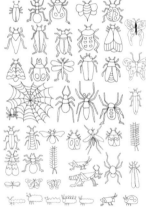

Insects and Spiders
pages 18–19

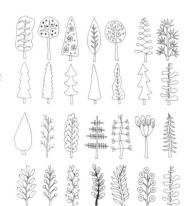

Trees and Fronds
pages 20–21

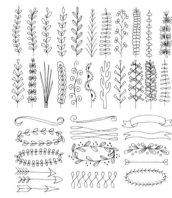

Branches and Laurels
pages 22–23

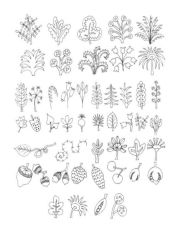

Growth and Seeds
pages 24–25

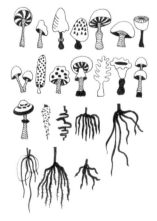

Mushrooms and Roots
pages 26–27

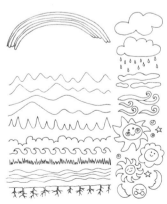

Landscapes and Weather
pages 28-29